Images of Malawi

Images of Malaŵi

a collection of paintings and prose
by
Monica Peverelle

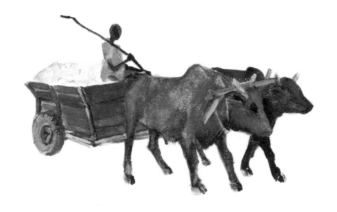

Central Africana Limited
P.O. Box 631, Blantyre
Republic of Malaŵi

First published by Central Africana of Blantyre, Republic of Malawi, 1991

2 500 copies of this edition have been printed of which 10 copies have been bound in full morocco by the Syston Bindery, Leicester, England, lettered A to J. 100 copies have been bound in quarter morocco within a slip case and numbered 1 to 100.

———————————————

———————————————

ISBN 99908 14 007

Colour separations and reproduction by Fotoplate, Cape Town

Printed and bound by Creda Press, Cape Town

SUBSCRIBERS

Ackland, Joss and Rosemary
Air Malawi Ltd
AMI Malawi Ltd
Barlow, Frances
Barrow, C
Bishop, John
Blackwell, Les and Mary
Bruessow, Carl
Bruessow, Maximilian
Butler, V A
Chipofya, V H
Commercial Bank of Malawi
 Ltd, Training Centre
Connolly, E D
Foy, Christopher and Maria Da
 Assunção
Frenkel, Dietrich
Fromm, Deborah
Garland, Peter and Vera
Gibbs, M R
Heffner, James
Henderson, Mr and Mrs M J
Hinde, Nigel and Rosemary
Holzberg, Dr Sebastian
Hoogendoorn, Pieter and Nel
Johnston, Frank M I
Jubitz, Ray and Nansie
Kateifides, G
Kay, Mr and Mrs R C Cathcart
King, Dallas
Kimble, Dr David and
 Mrs Margareta
Kippax, Frank and Iona

Kirkcaldy Trust
Lawrence, L R G
Limbe Leaf Tobacco Company
McLean, Sandy and Joan
McLean, Jonathan
Mapunda, H R
Mitchinson, Robin
Mobil Oil (Malawi) (Pvt) Ltd
Molina, Dr Maria Ines
Macintosh, Gordon
Nicholson, Ken
Okhai, Kassam
Palmer, Peter J
Peverelle, Monica and John
Richmond, Tim
Roseveare, Lady Margaret
Russell, Mr and Mrs D F
Sacranie, Margriet and Hamid
Schwarz, Mr and Mrs A
Sherwood Export Company
Stuart-Mogg, David,
 Patricia and James
Stumbles, R A
Testi, E E H
Unitrans Malawi Ltd
Velthuis, Anneke G
von Ribbeck, C Henning
Wallace, S W
Watson, Mr and Mrs N A
Wouters, Han and Tina
Wrixon, Robin
Young, Ian Jardine
Young, Anne Jardine

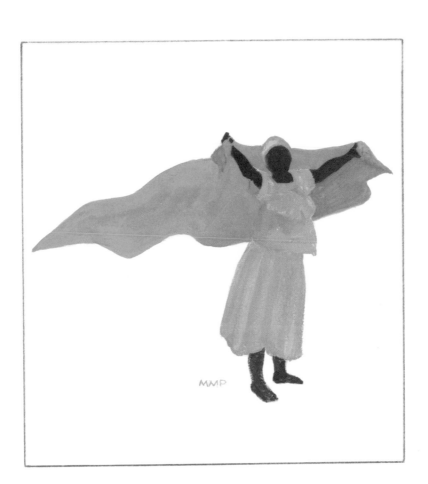

First of all
meant for the Peverelles,
now,
happily, shared.

1991.

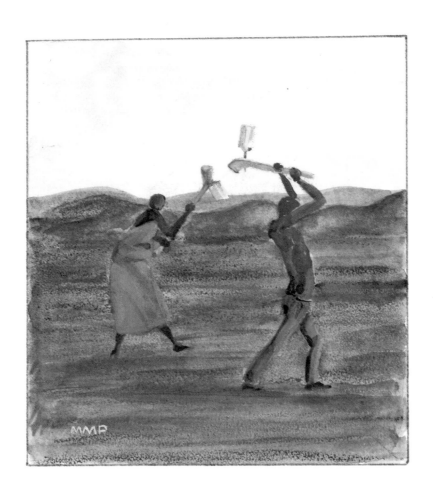

This collection is
a tribute to both Malawians
and Malawi, for
it is the innate dignity,
courtesy and good humour
of the people
that made it possible
for me to discover, and
consequently grow to love
this land.

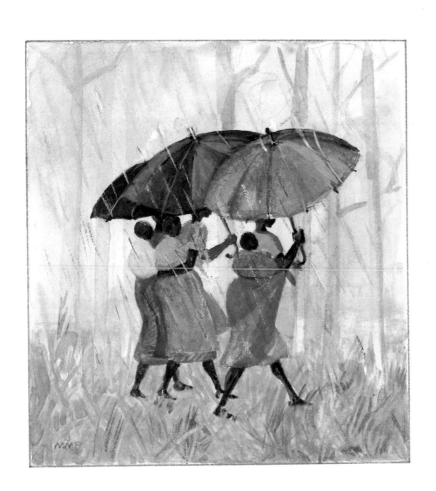

"Images of Malawi"

The sequence is as follows:

Backdrop.

The Road; using the
endless African road
to string together, randomly,
the people, poetry
and places.

Game Reserves.

Lake Sojourn.

Garden and Khonde.

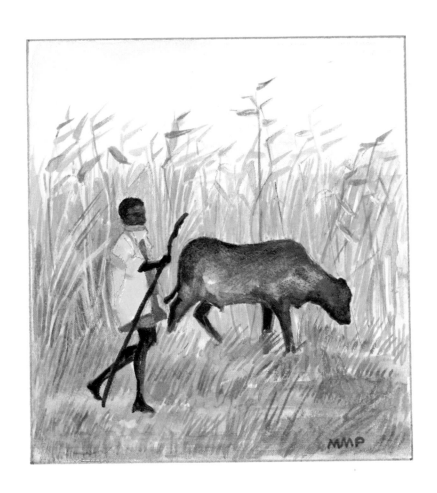

When the African landscape
is so vast it looks as an
endless sea, when the colours
therein fade in perfect
harmony, all the way to the
far horizon; then
there is
a moment of truth
and
undeniable beauty.

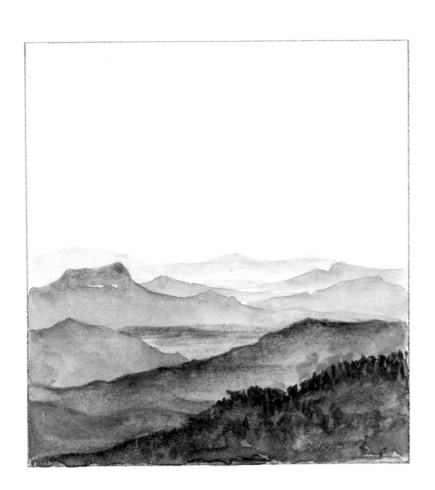

Nestling
beneath the hills
lies
the
Lake,
jewel of Malawi.

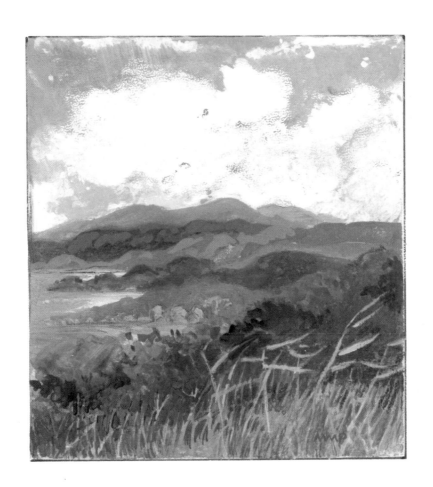

The gold, the blue,
ghost of moon
in sun-blanched sky —
the wild fig's spreading
branches, laden
with new fruits
of palest green.

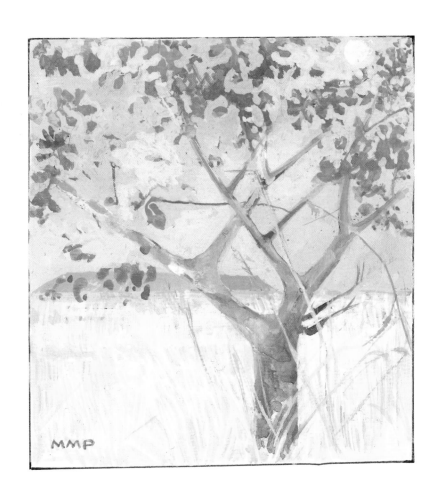

Warm,
quiet peace
of Sunday in the bush
and the sudden
lifting into the air
of myriads
of fluttering white butterflies.

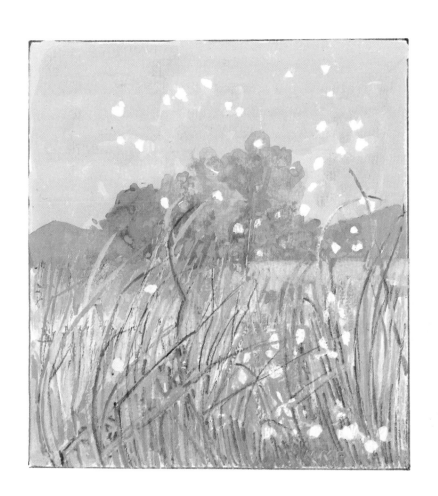

Just
as the heart
of the Cissempelos
is caught
and held
in
the bush —
so too, is mine.

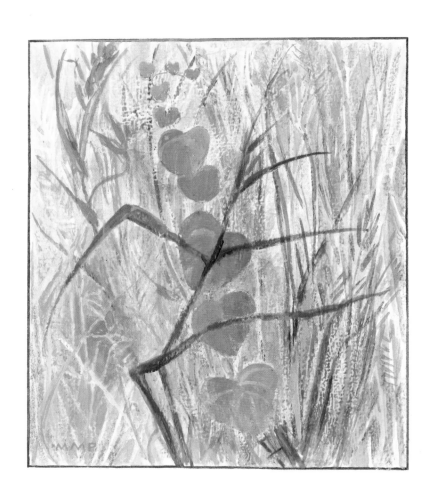

Any place
at
any time
the Tearoom
is open
to supply basic needs
of bread,
tea
and sugar.

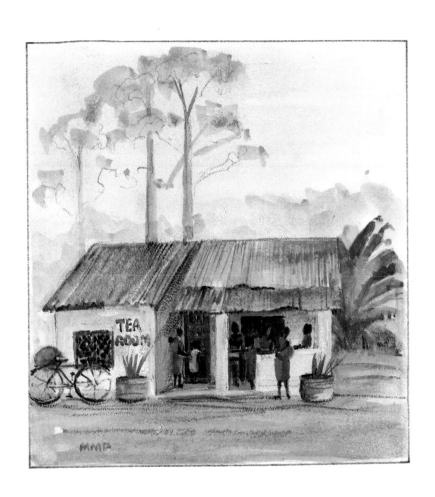

How they hoe!
the families
who live upon the land,
working,
toiling
to produce
food enough for all.

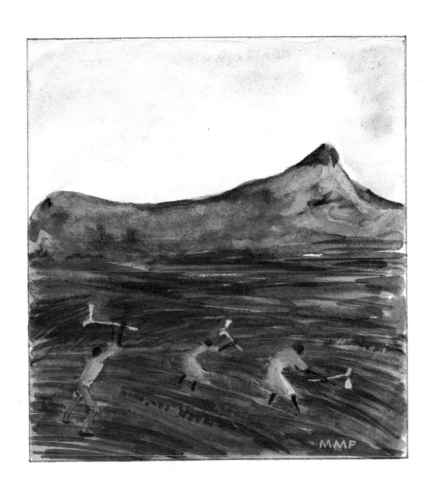

A shock of red
glimpsed through the trees
reveals
a dramatic landscape, and,
yet again,
the industry of the people
is in evidence —
tilled,
turned
and waiting,
waiting, waiting, for
now late rain.

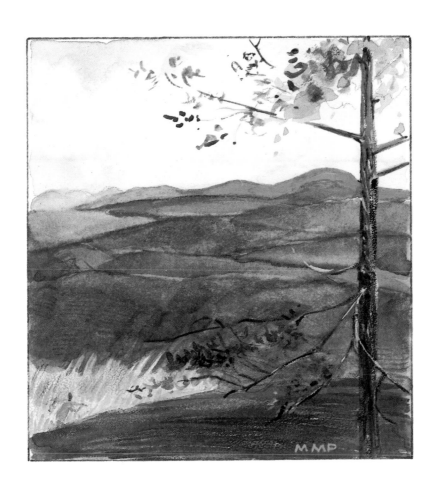

The earth is tilled for as far as
one can see, and the rich red
plain lies in waiting – for both
rain and replanting.
A sighing breeze
passes over all, and
a single russet leaf drifts,
mid dance above the furrows,
floating,
flirting,
falling
in the balmy afternoon.
Yesterday,
today,
tomorrow,
part of an eternal harmony.

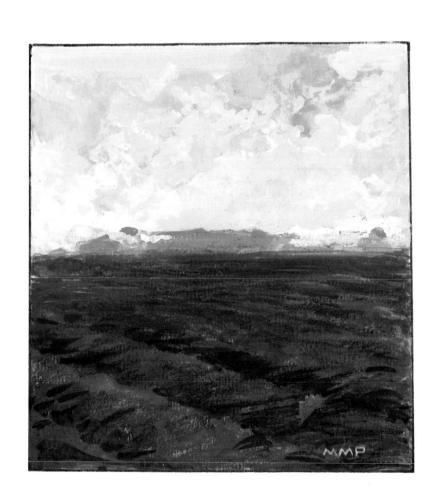

Blue, blue, blue
sky blue
hills blue
shadows blue
A symphony in hues of blue
all shapes defined
yet blurred
as distance lends its magic.

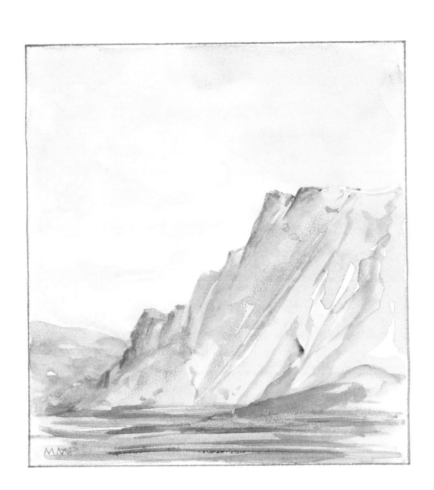

In the shade
of the mango tree
two women sit —
their dresses of pink
and sunfilled yellow
sing!,
like perfect notes of music
light and dark,
sunshine and shadow,
Africa!

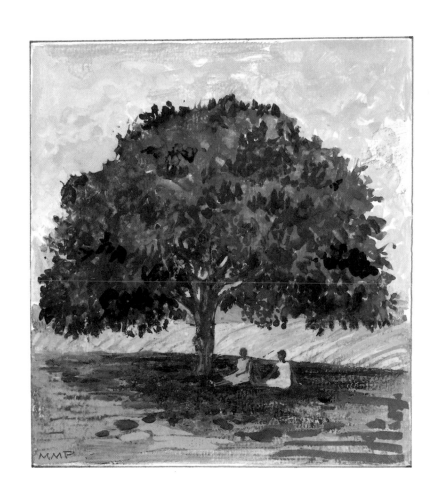

Fresh, cold early morn,
a buffetting wind shakes,
tosses and rattles
through the topmost
branches of the gumtrees –
recreating
albeit so far inland
the
turbulent sound
of a
restless sea.

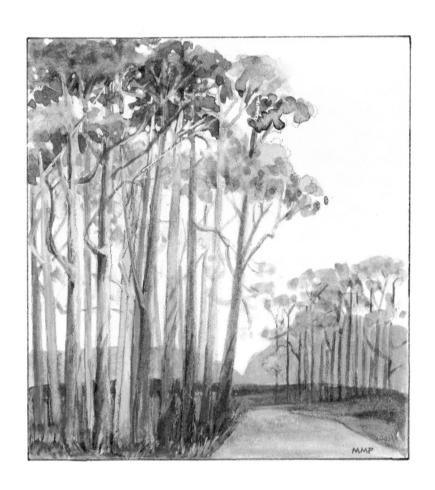

Beside the road,
the
endless,
African
road.

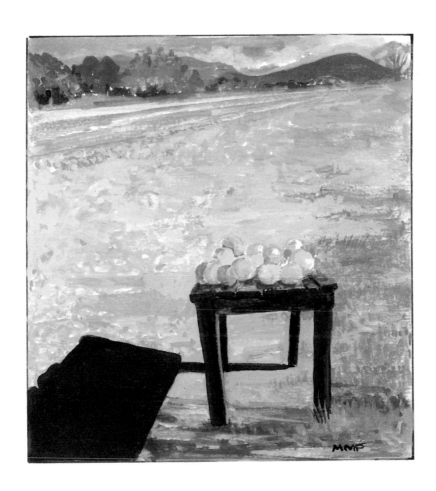

Plump pumkins
for the picking —
piled perfectly,
placed
particularly!

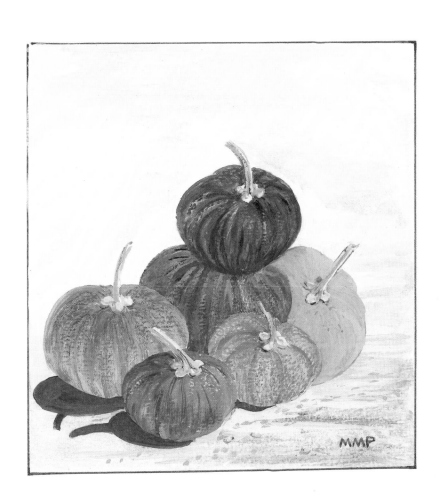

Such a good feeling
of well - being amongst
the womenfolk
as they
walk
to market,
a gayness
and optimism
that goes well
with
the
sunfilled morning .

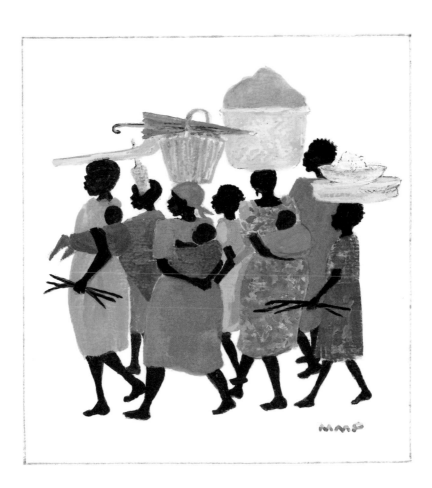

The tinsmith
clangs and bangs
(like the blacksmith
at his anvil)
sure, strong strokes,
simultaneously using
and
conserving
energy
as he
shapes his pots & pans.

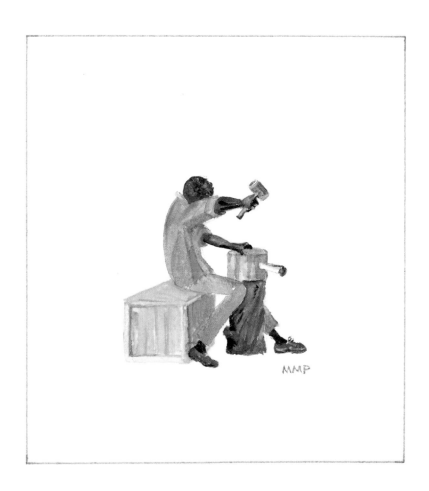

Emerging like butterflies
from
the tall golden grass,
the children
run home from school,
myriads
of children,
where do they go?
where will they go?

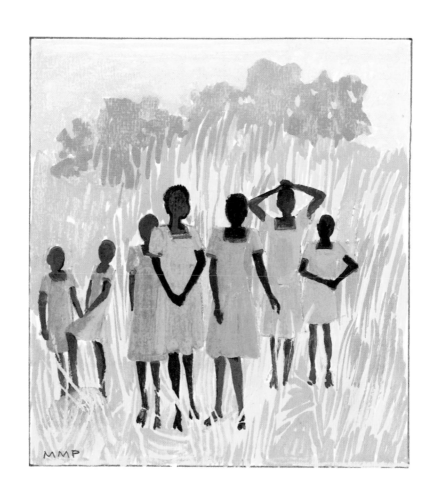

The edge of the road is
momentarily,
briefly, afire, with
a luminous diffused glow....
as the last rays
of this day's sun
touch upon
the
billowing clouds of grass.

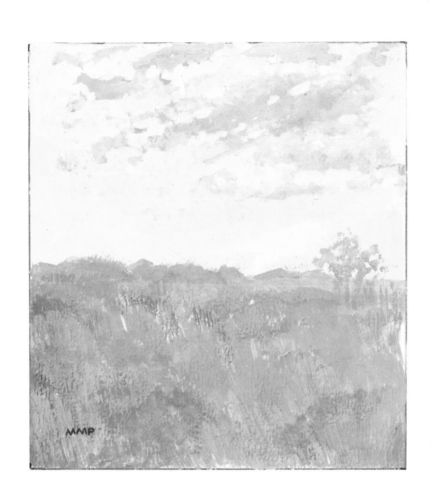

A table stands
laden with fruit,
beneath
a few eggs
are carefully placed –
all displayed
with quiet pride,
and should you stop,
a courteous vendor
will
attend you.

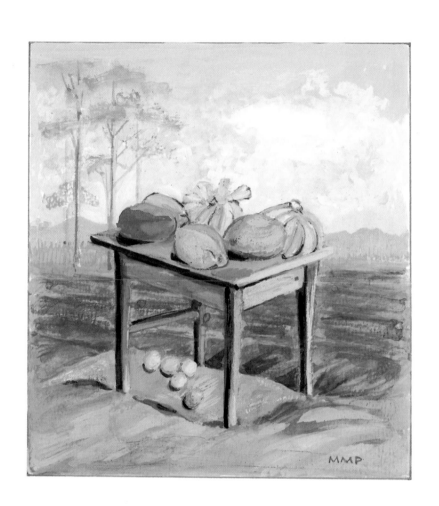

Another day closes,
and in so doing,
the swiftly
sinking sun,
creates
a jig saw
of
dappled light .

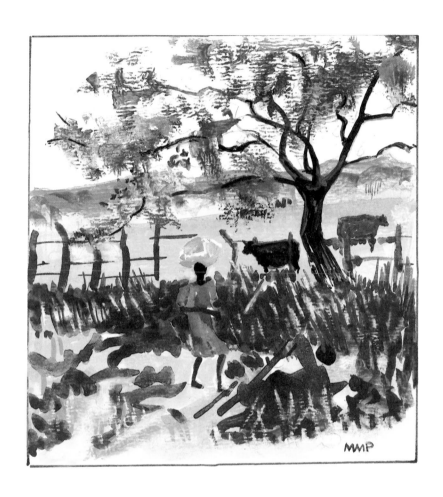

Her skirt twirls
as the wheel she whirls
Lift and fall,
now short, now tall
Push and pull
'til the pail is full
Such grace
in the dance at the wheel.

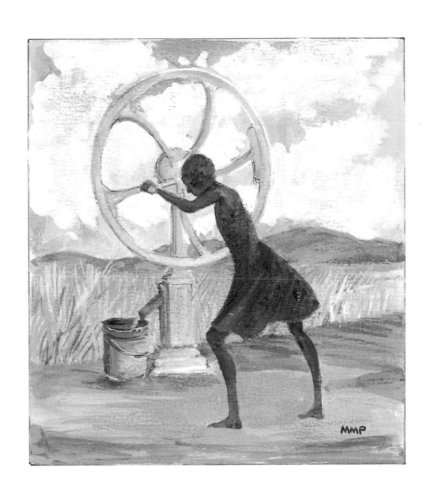

Entwined
in special friendship.

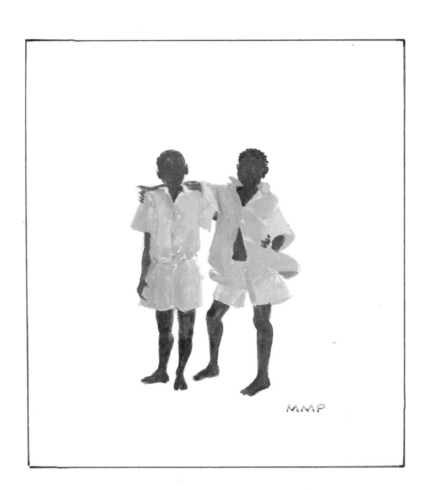

The prestigeous
bicycle.

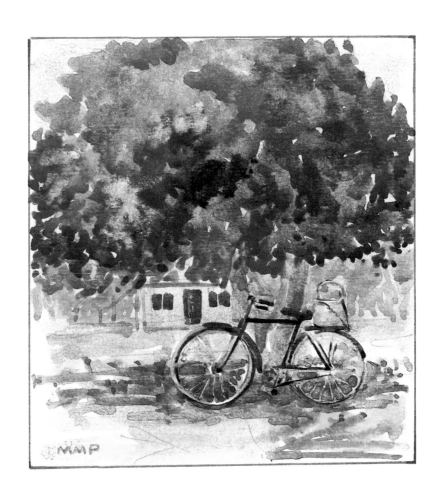

She unfurls her chirundu,
caught
by the breeze
it
billows
and blossoms
like a flower.

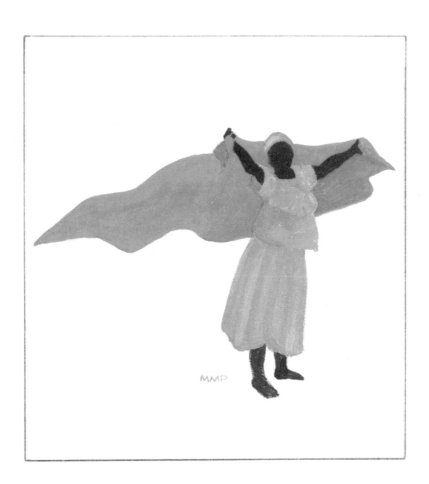

The road
winds on and on
into
the oh-so-sweet soft blue
mountains
that flower in a cluster
on
the distant horizon

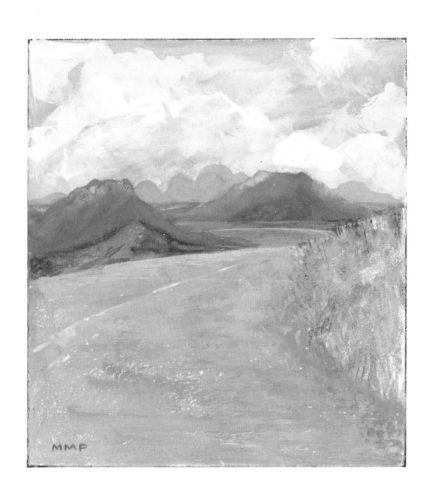

The men
gather
at the bicycle repair shop,
the social side
of things
quite as important
as the practical!

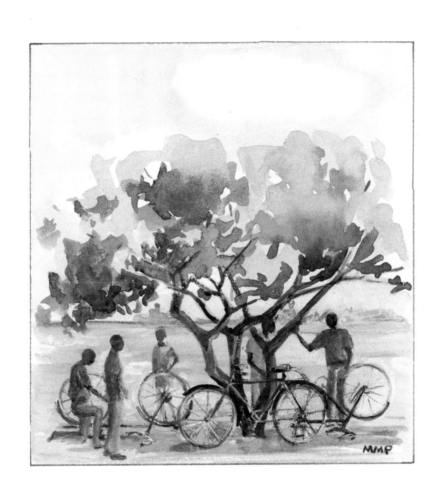

Rolling,
bowling along
the
road,
(discarded reins!)
a boy
is
king
for a few glad hours.

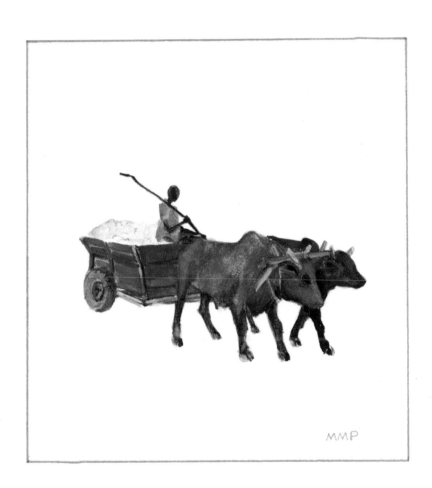

After months of rain
abundant waves
of pink
and mauve cosmos
envelope
children
to the waist.

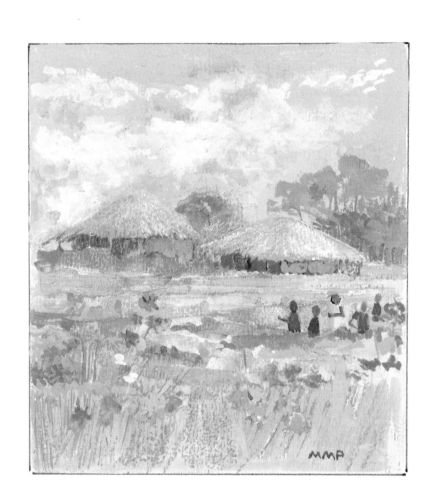

Pumpkins
progress,
prettily
poised!

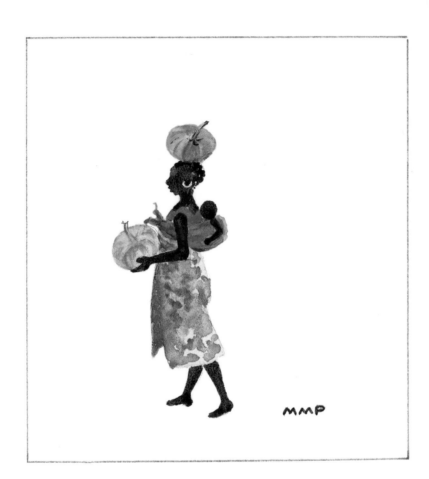

Intensely warm,
breathless,
soporific –
the cyclist
and his passenger
move
forward
with almost
insolent disregard
for the prevailing heat!

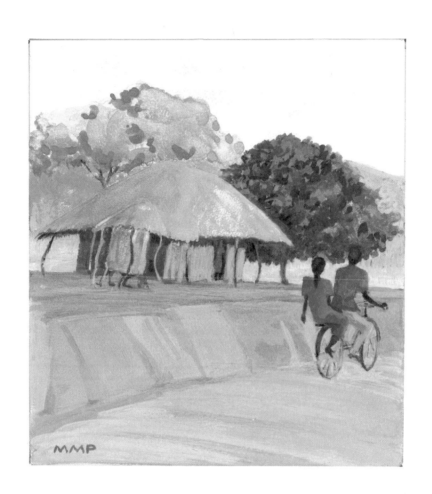

With regal carriage,
back and shoulders straight
she
bears
the heavy water vessel
with
easy grace.

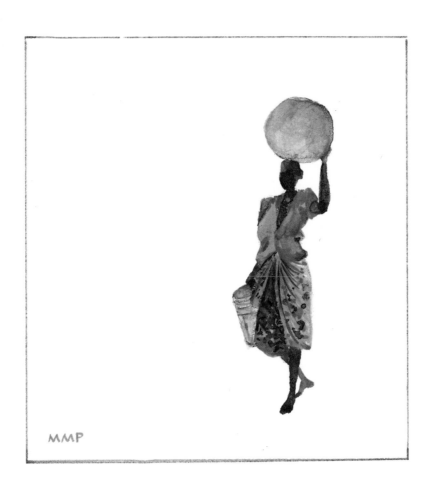

The enormous weight
of timber
is both felt and seen
in the tension of his
carefully controlled
gliding gait.

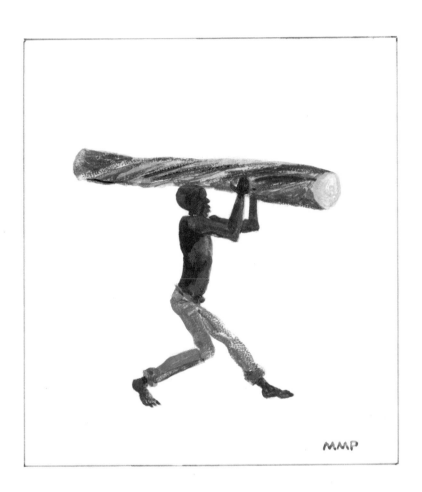

The children

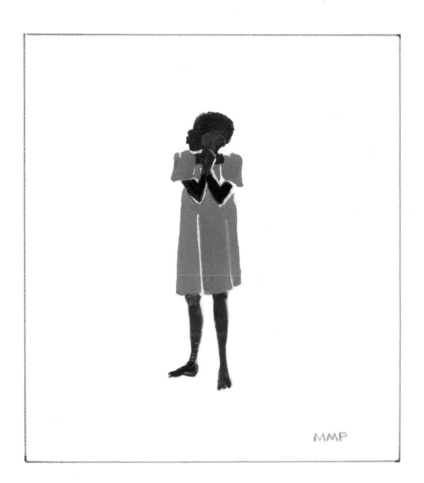

MMP

Beside the road,
briefly glimpsed — this
delightful
and
diligent
scene.

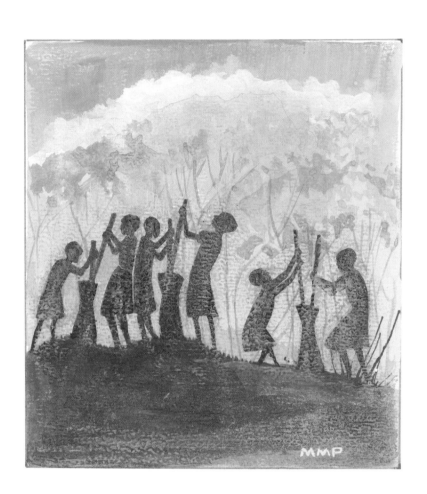

There is a timeless grace
and beauty
in
the unaffected poses of
the
children;
a
constant magic.

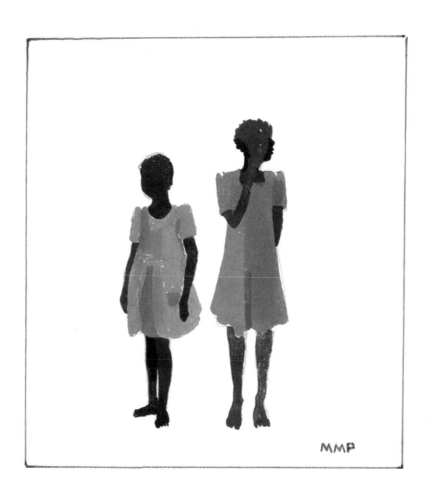

MMP

It is still cool,
later in the day it will be very
hot —
no-one about yet, 'till
these two girls emerge
from the overgrown and
tangled grass.. out
early
to collect water
for the day.

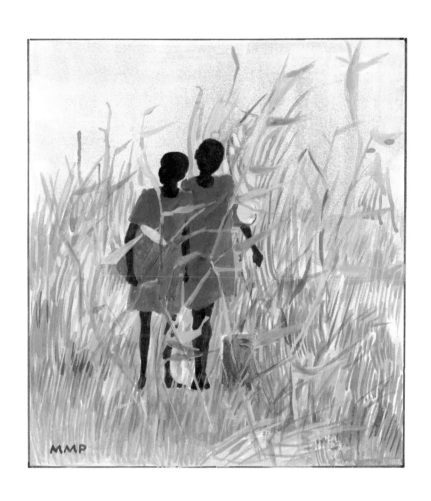

The boys,
young as they are
already
a sort of cocky strutting
in
their walk!

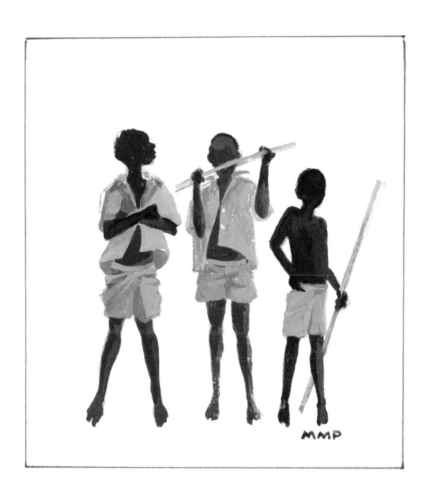

Two girls
with the narrow defenceless
shoulders of childhood.
Two straight & guileless
figures.

Two rectangles of
solid colour.

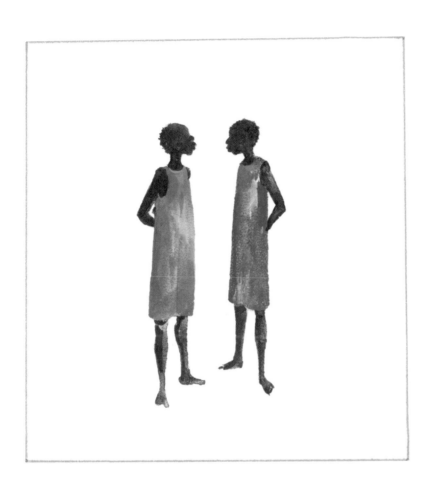

On Saturday morning
dogs are taken to the dip,
and
here
proud ownership
is
evident!

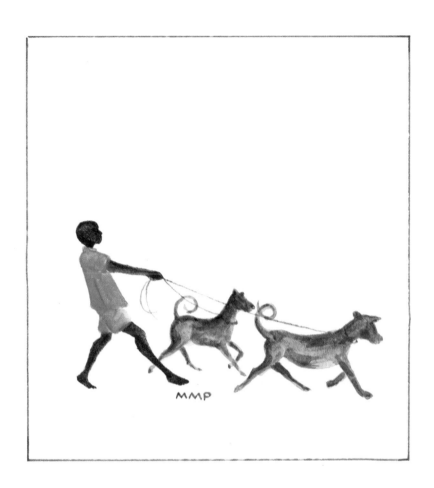

...... that same pride
of ownership clearly seen,
even in the (seemingly)
most casual
of
masters!

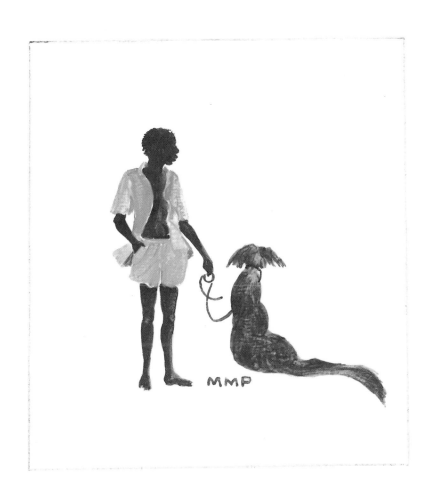

Sky pale, clear,
grass wet with dew, and
into morning light
walks this wraithlike
file of men ... each
carrying on his head the
tall mtondo in which
the maize is pounded.
A silent
and satisfying scene —
men
taking their wares to
market, with calm
and
purposefulness.

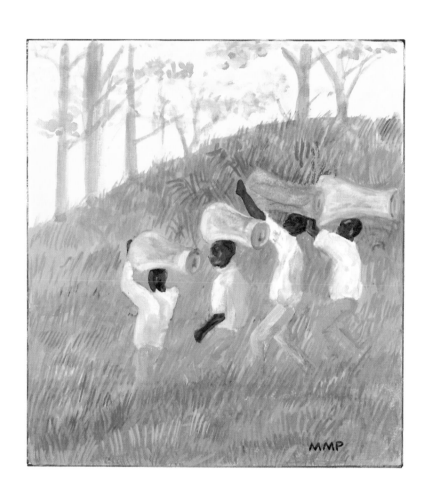

So many
tailors,
sewing seams
on
khondes,
stoeps
and
shop fronts

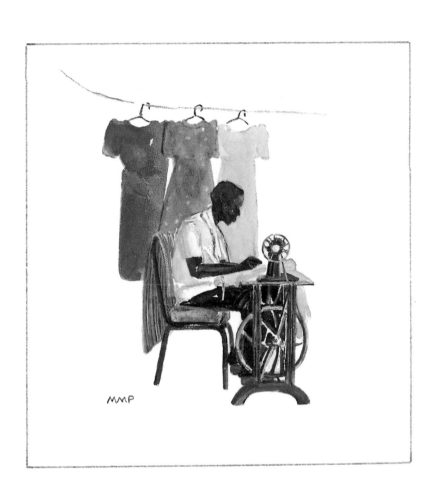

Placidly
pushing,
patiently
plodding,
piled pillion
progresses.

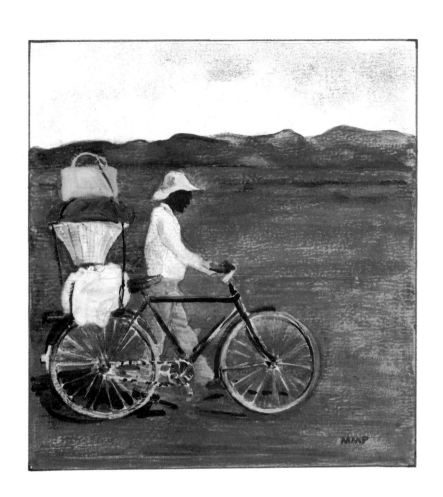

Ndirande Mountain,
(the sleeping man)
rests between
Limbe and Blantyre,
his
distinctive profile
looking
to
the heavens
for all to see.

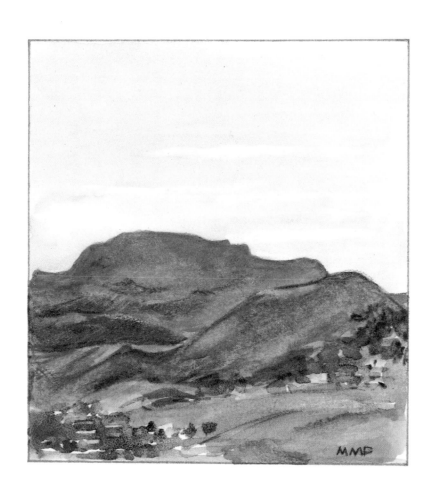

Starkly
contrasting,
black trunks
make
linear patterns
'gainst the golden glow
of
cosmos.

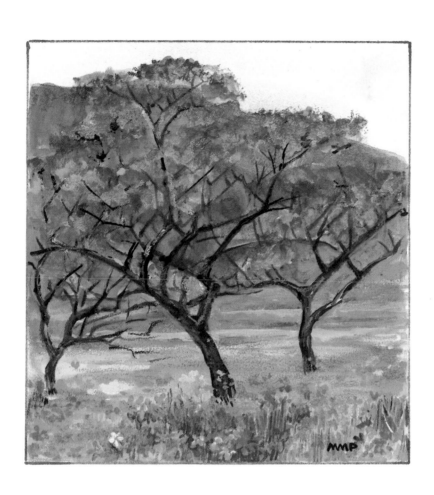

a
world
where paths
lead through the sky,
on the escarpment road,
going
down
to the valley.

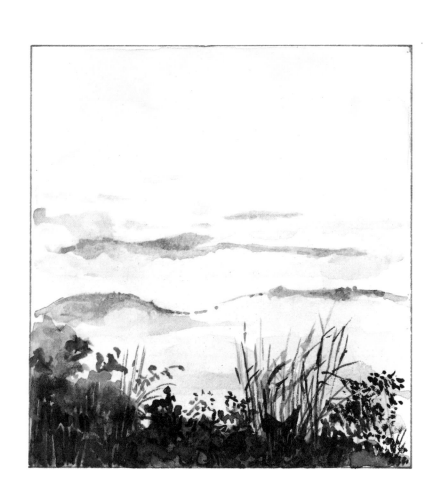

A jaunty stride,
a contented boy,
dreaming
perhaps
of the hoped-for catch
as he moves along
the bank of the river.

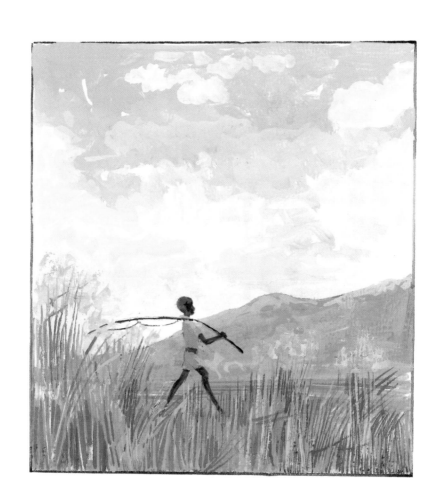

Overlooking the tea,
Mulanje Massif
a pale shape on the far
horizon; in between,
the great plain flickers
and shimmers
in the heat, mid-day
somnolence
envelopes all,
yet, simultaneously
a vibrant life force
emanates from the verdant
green bushes.
An absence of sound
creates a feeling
of unreality and of
time
suspended.

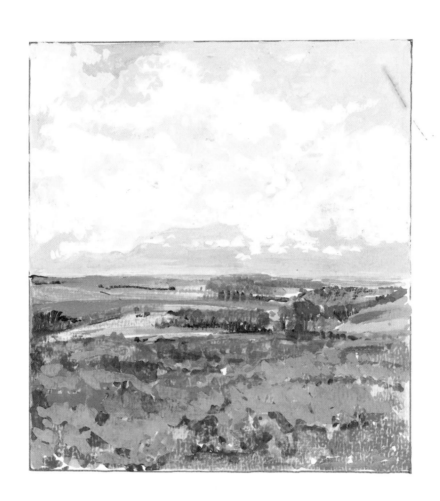

Brief respite
for the traveller
going somewhere,
as yet far from anywhere
on
the
long,
hot,
dusty
road.

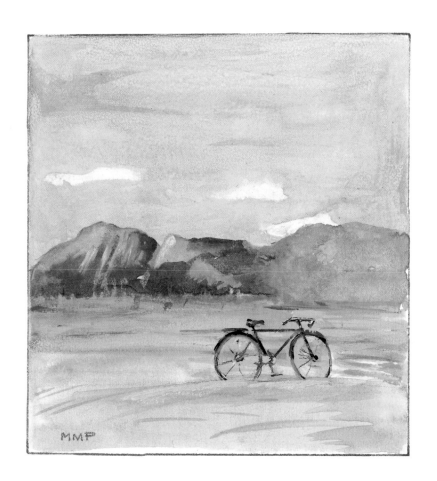

Nyanga Peak,
this mass of rock
thrusts upward to the sky,

grey,

solid,

massive,

part of the most aptly named
Mulanje Massif.

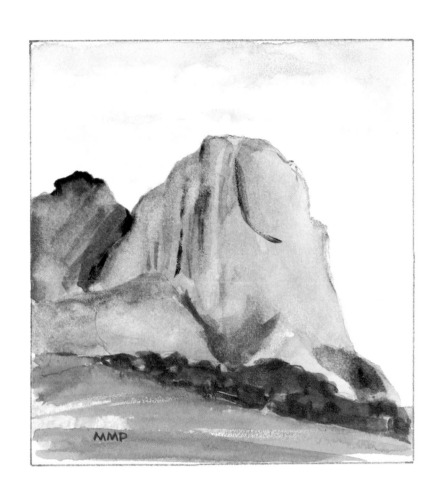

Discover
the coursing river
as it surges down the
mountainside —
scorch the soles
of your feet
on sunbaked rock;
find
penultimate bliss....
immerse yourself
in the
ice cold water!

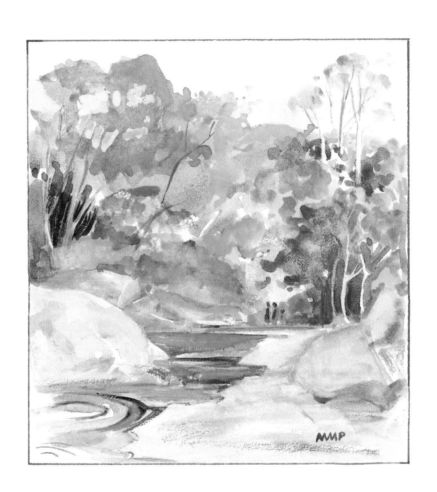

The hills roll away on either side
of the road, falling
in gentle curves, flowing
downward toward the floor
of the valley where they meet,
melt, overlap, kiss
and peter out into a fertile
bed, through which
snaking paths wind
endlessly.
The sides of every hill are
tilled and one sees patches
of earth exposed in a rich
variety of hue and colour —
all interspersed
with dried yellow and buff
swathes of grass.

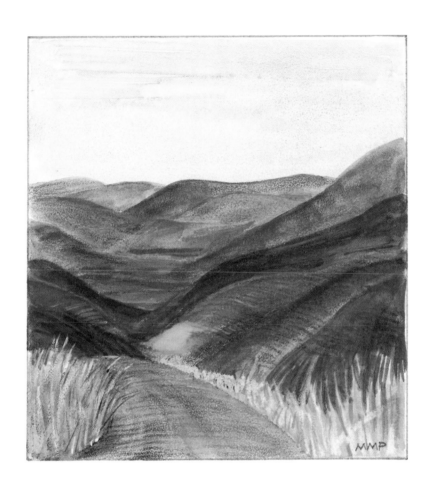

High
on Dedza Mountain
the aloe
thrives
upon
its bed of rock.

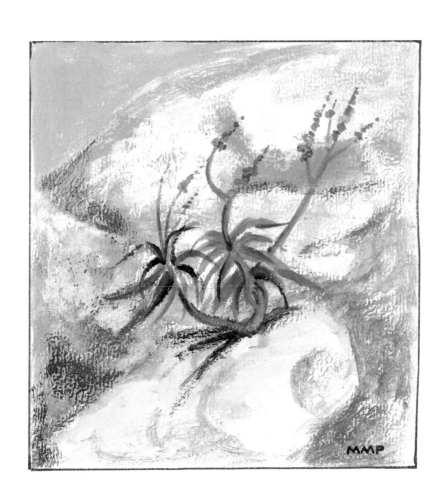

Bathed
in sunlight,
the Brachystegia
springs to vibrant life,
welcoming
African summer
in silent,
jubilant
song!

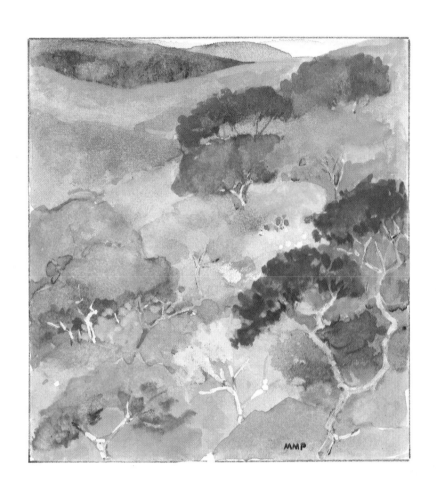

A water ballet,
where men
are dipping,
lifting,
vast gauzy nets —
poling,
pushing,
fishing in the shallows.

Chia.

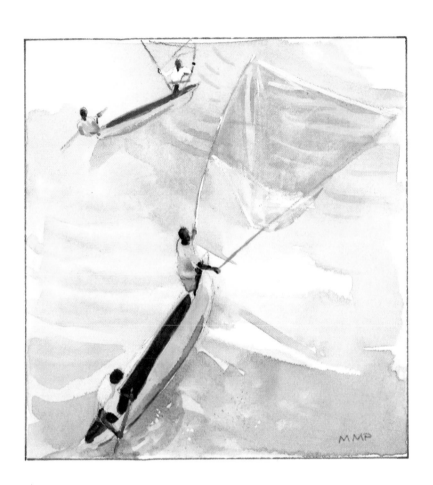

This
dreamlike panorama,
neat,
tidy,
vast,
almost empty,
except for
the occasional animal
set down,
toylike,
against the hills.

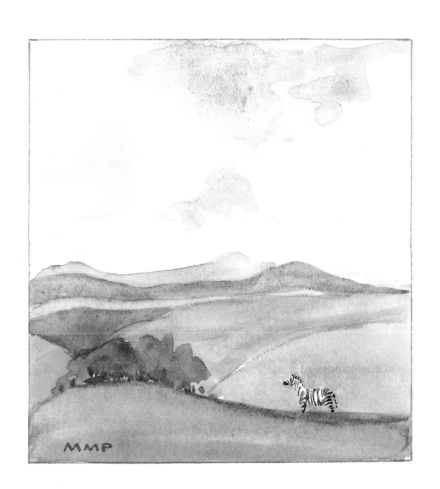

Alone
in the vastness,
lightly
leaping
against
a luminous sky.

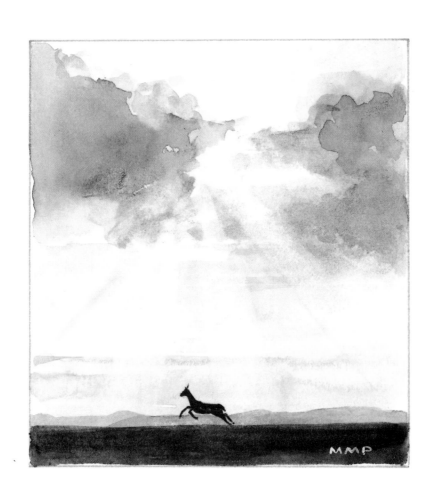

The hills are covered
in winter's trees, right to the top
they stretch, twigs, branches,
trunks, all reaching to the sky,
and, set within this gently
coloured mat, a very few
trees gleam, already in their
summer dress, gloriously
lit by the sun;
yet other trees, a meagre few,
are lacy white in winter
nakedness, set as pieces
of filigree
'gainst the quiet colours
of
winter's resting trees.

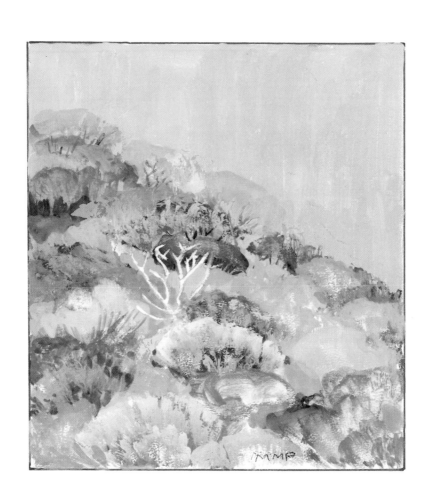

The tawny grass
is high no more,
the land lies in repose
waiting,
waiting,
waiting for the rain....
and passing through
are the inevitable
strings of warthog,
bristling, bustling
busy
and brisk!

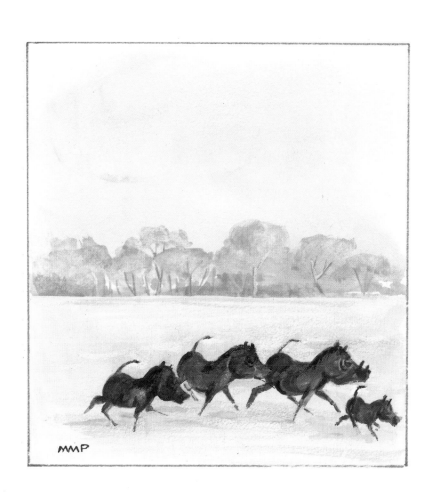

After the bush fire,
charred little trees
wave russet leaves,
brandishing,
blatant,
brave,
'gainst the burnt
earth's blackened coat.

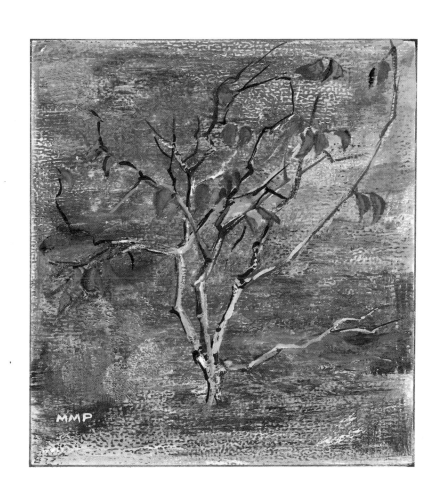

The leopard
drops from the tree,
streaks across the track
into the pale, dry
end-of-winter grass; he
becomes a rusty blur —
rising, falling,
powerfully,
rhythmically,
now seen, now unseen
as he surges through
the golden swathes...

cont:

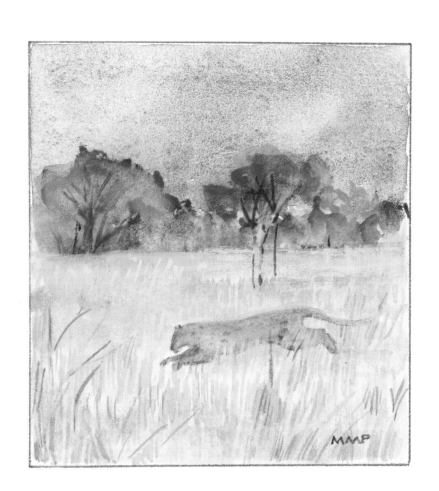

the sequel
a magnificently
primaeval scene, for as
the leopard flees,
so a great baboon barks _
barks again, and again,
warning
the entire troupe
of
passing danger.

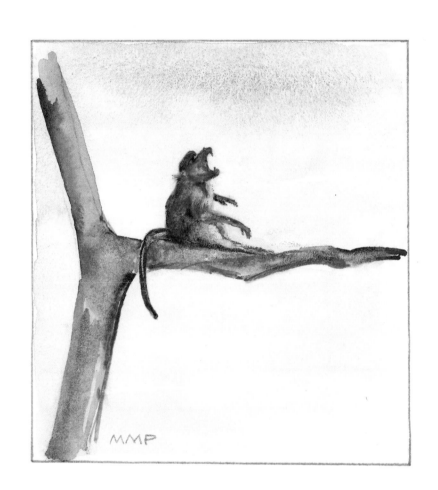

Glade of golden grass.
Black etched
the lacy branches.
Pricked ears

on slender necks.
Shaved sides, red blonde.
Momentary stillness
and then,
silent flight.
An empty glade
of golden grass,
warm and still
September afternoon.

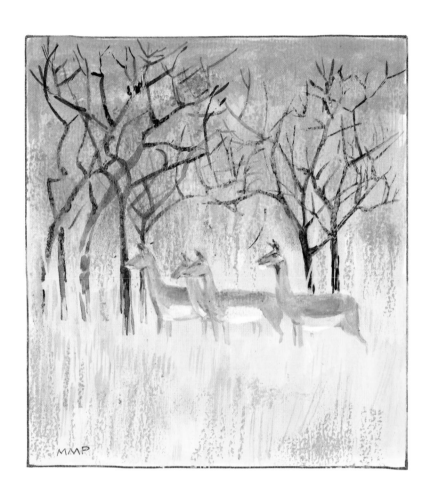

Relentlessly
the snake-like creeper
wraps itself
about its host —
growing evermore
strong and
strickening.

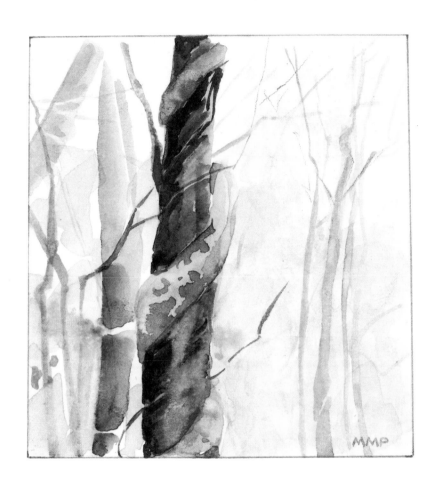

The Baobab,
great grey giant
cavorts in the bush....
at once bizarre,
grotesque—
yet,
with familiarity,
endearing too!

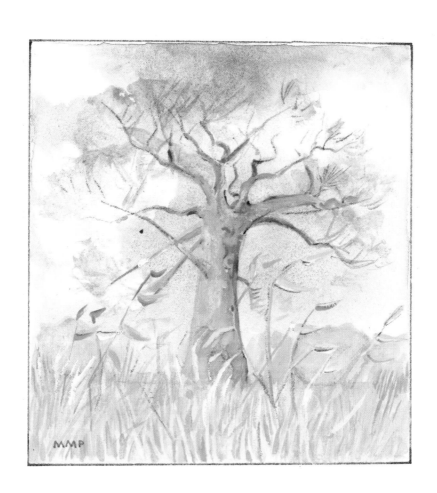

Contemplate,
ruminate,
wile away the hours
in this
part
of paradise.

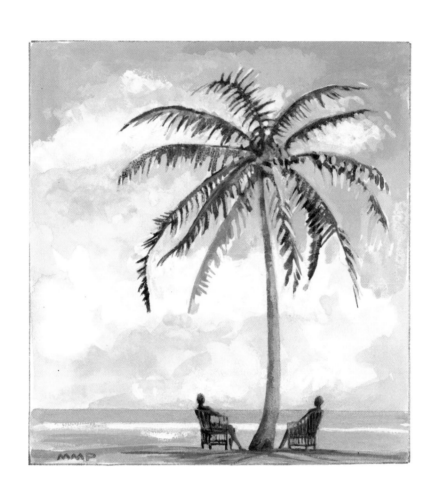

Egrets
wing whitely
through the blushing sky.

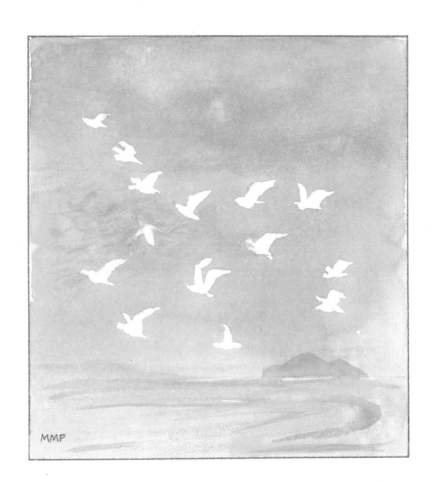

The ancient tree
stands sentinel again tonight,
barely visible
against
the blue black sky.
The distant throb of drums,
the deep insistent beat
carries
across
the
still,
dark
lake.
A night both aeon's old
and
ever
young

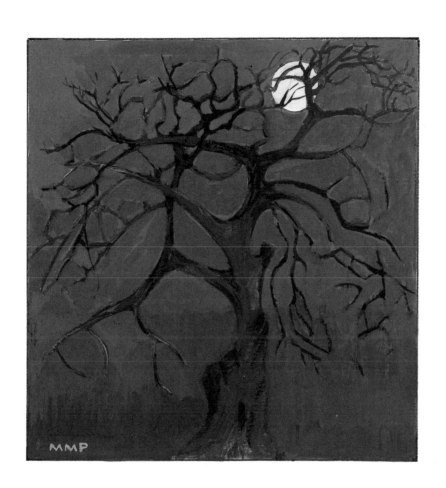

Sharing
the
sunrise .

Treetops. Lake Malawi.

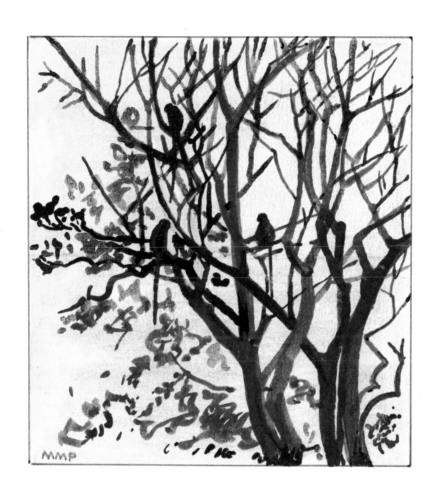

After
last night's fishing
the dugout is beached
at first light,
the nets checked,
repaired,
made ready again
for this evening's catch.

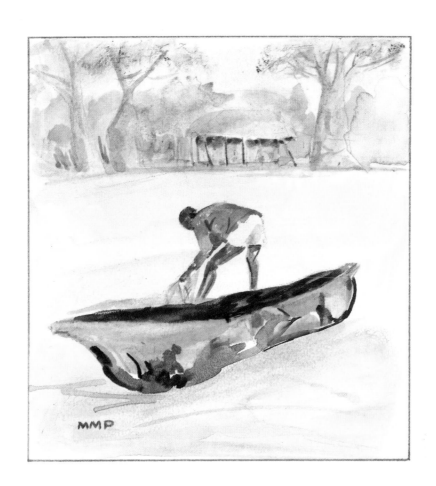

Before
breakfast
the fisherman arrives
at
the door
with the fresh catch,
and
who can resist chambo
straight from the lake,
for the table ?!

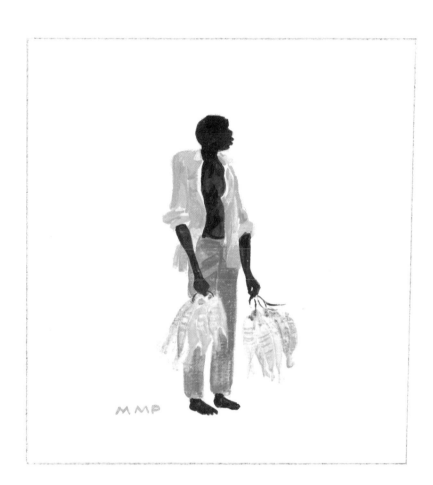

Blue, white, silver,
shining
satin
smoothness,
still,
sublime
serenity.

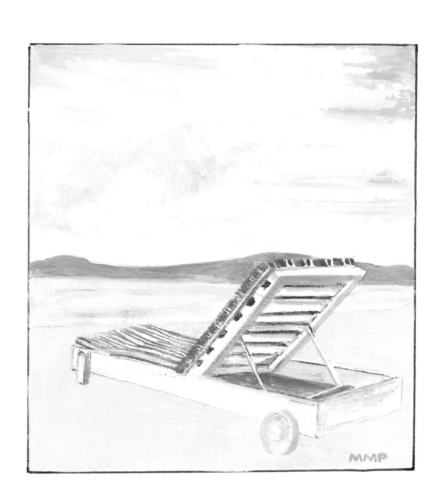

In golden light
he sets the nets.

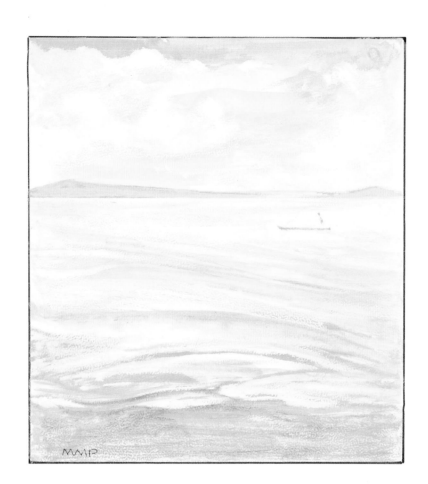

Rolling rhythmically,
with
each thrust of the pole a
surge forward
through the shallows,
returning
to shore
with silvered catch.

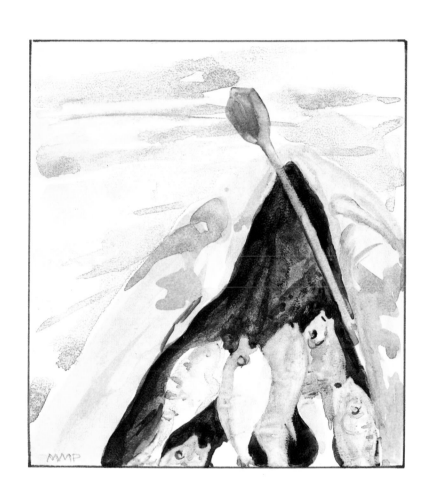

Her name is Waliya,
her chores
take her daily
to
the edge
of the great lake.

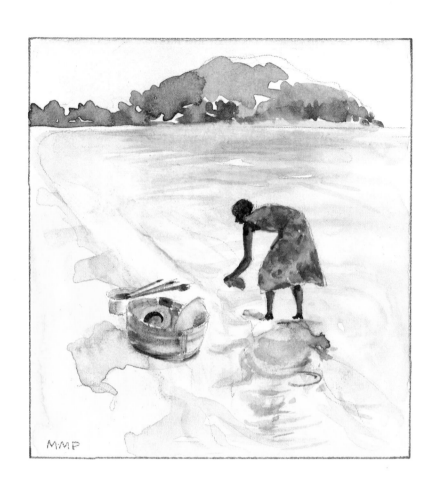

Silently
he plies the glassy mirror
of the lake,
disturbing the surface
as a gnat
upon
a
pond.

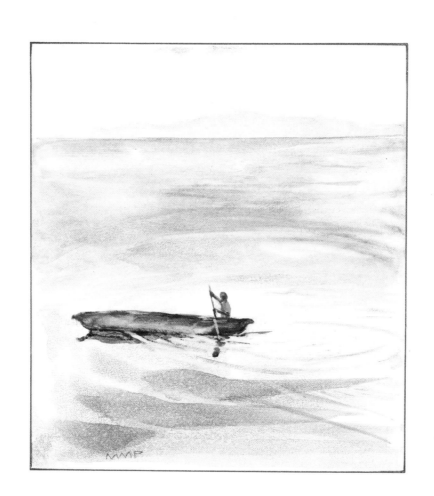

A morning
colourful,
clean,
clear,
cool.

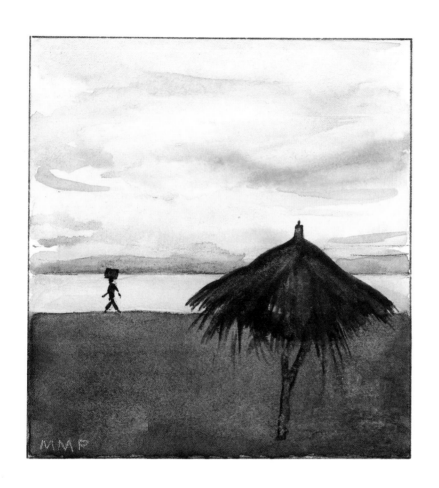

The moonlit sky is softly
luminous tonight, the air
is warm, caressing,
the matt black lake
lit by moonlight, heaves and
curls – slaps the shore,
splish, splash
after mid-day calm.
It is as if in this timeless
place, one is held for a
moment
in the world's embrace.

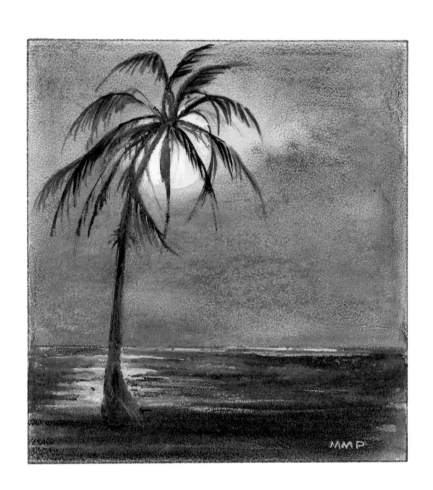

The grandeur of the
Fish Eagle in flight
supercedes
the October sun
which (with the dust
in the atmosphere, prior to the
rains) both begins and
ends the day
with a scarlet
ball of fire.

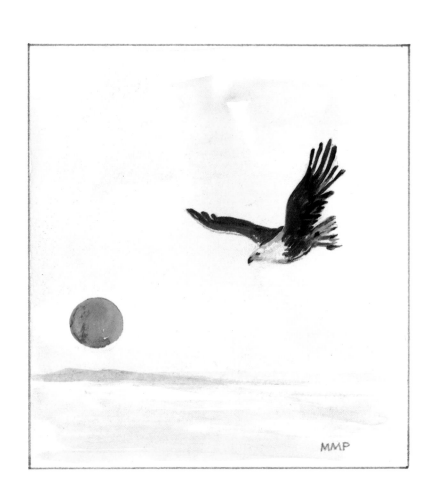

Delicate, graceful,
and reminiscent of a
Chinese water-colour,
the Bougainvillea dips
and
cascades
over
the bird bath .

Returning to khonde & garden.

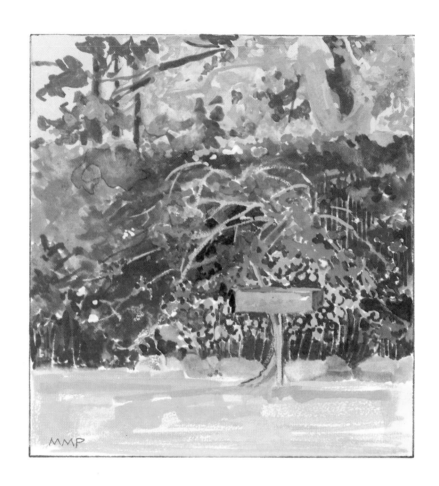

The jacaranda heralds summer,
its acrid scent promises
another warm day – and
the branches darken as
blossoms envelope the tree in
a cloud of mauve blue and
purple, then, for a time
a kind of unreality prevails
and a dreamlike quality
enfolds the landscape 'til the
blossom falls and the tree
becomes green like any other!

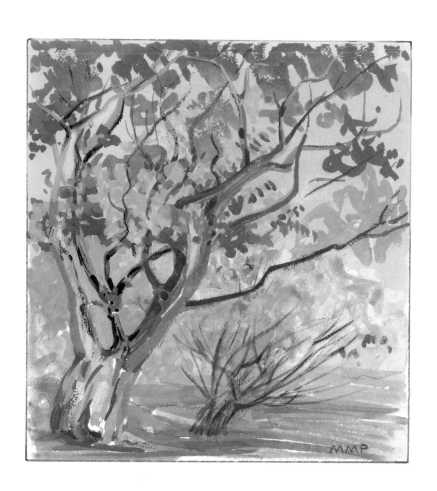

Just before sundown
the Hueglin's Robin appears
to take up his favourite
perch
atop the waterwheel,
and there
he trills
his last goodnight.

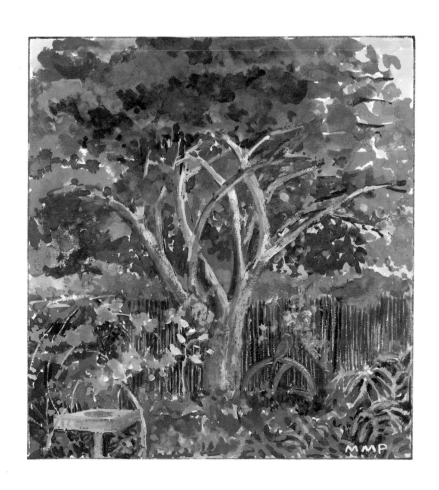

Keep
this chair
for me,
one day I will return
and shall
sit in it again!

Jean's visit.

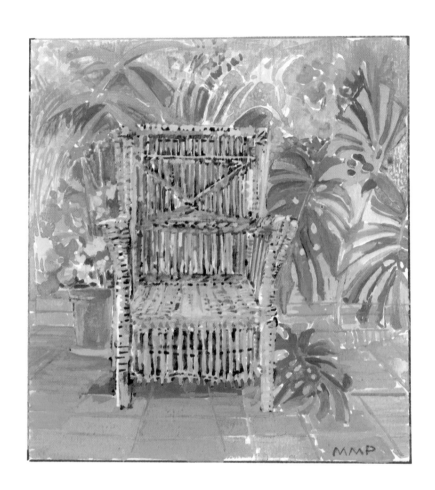